THE URBANA FREE LIBRARY

W9-BCD-328

DATE DUE		

DISCARDED BY THE
URBANA FREE LIBRARY

The Urbana Free Library

To renew materials call
217-367-4057

農民畫裡的故事
Everyday Life

THROUGH CHINESE PEASANT ART

By Tricia Morrissey and Ding Sang Mak

URBANA FREE LIBRARY

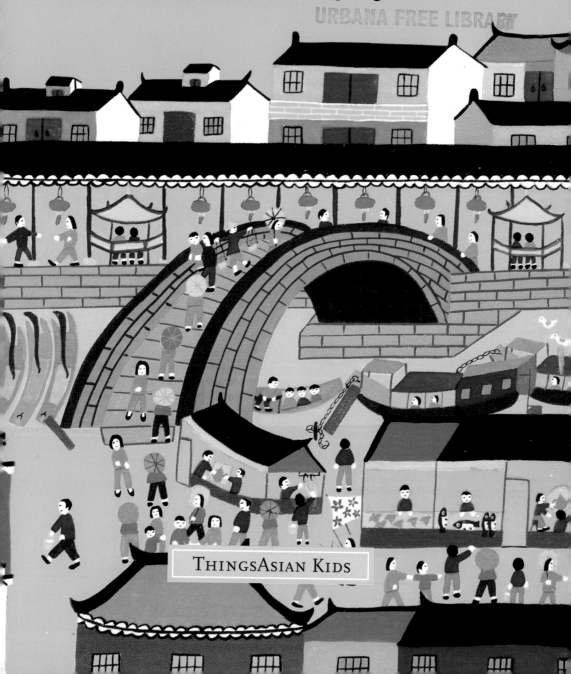

ThingsAsian Kids

5-09
12.00

For my parents, who introduced me to a very big world – T.M.

Everyday Life Through Chinese Peasant Art
By Tricia Morrissey and Ding Sang Mak

Cover and book design by Janet McKelpin

Copyright ©2008 ThingsAsian Press
All rights reserved under international copyright conventions.
No part of the contents of this book may be reproduced or
utilized in any form or by any means, electronic or mechanical,
including photocopying and recording, or by any information
storage and retrieval system, without the written consent of the
publisher.

For information regarding permissions, write to:
ThingsAsian Press
3230 Scott Street
San Francisco, California 94123 USA
info@thingsasianpress.com
www.thingsasianpress.com

Printed in Malaysia

ISBN 10: 1-934159-01-8
ISBN 13: 978-1-934159-01-9

"If you want to catch a fish,
go home and make a net."

臨 淵 羨 魚
lín yuān xiàn yú

不 如 退 而 結 網
bù rú tuì ér jié wǎng

– Chinese Proverb

Spring's whirling double dragon dance. A summer sky full of kites. Autumn's noisy harvest festival. A winter day building snowmen. In the Jinshan district of Shanghai, China, the farmers have learned to paint! From their brushes come pictures of their bustling lives.

在中國上海的金山區，農民一面耕種，一面把農村生活繪畫成作品。他們種的西瓜、稻等，他們的耕種、收成生活，變成紙上"雙龍飛舞"、"豐收"等等，變成繽紛多姿的農民畫。看看他們怎樣利用彩色畫筆，把農村生活畫成色彩繽紛、多姿多采的作品。

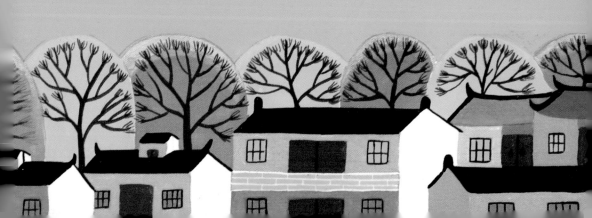

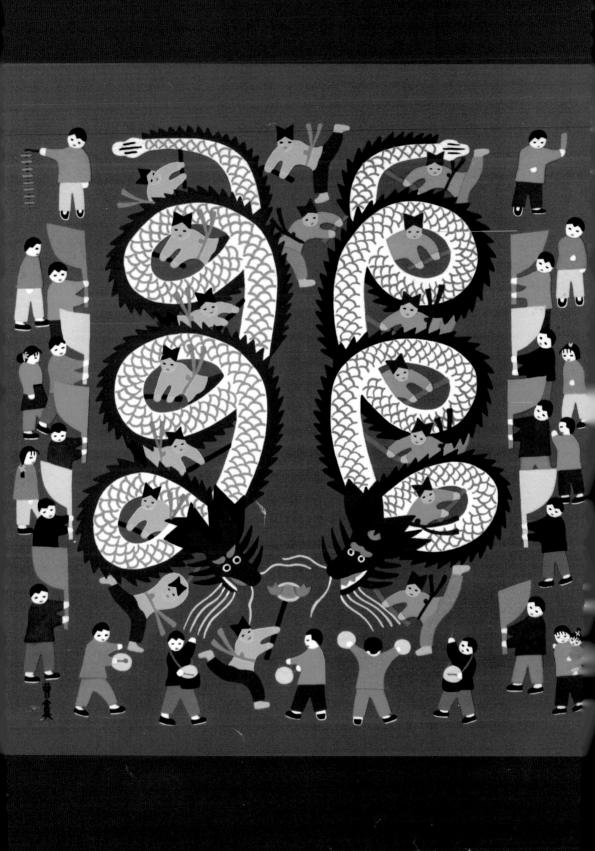

Double Dragons Dance

Crash the cymbals! Beat on
the drum! Leap to the sky!
Roll to the ground!
Double Dragons welcome
the year with swirling dance
and roaring sound!

新年鑼鼓咚咚響

xīn nián luó gǔ dōng dōng xiǎng

雙龍飛舞不尋常

shuāng lóng fēi wǔ bù xún cháng

人人喝采鼓掌中

rén rén hē cǎi gǔ zhǎng zhōng

飛天遁地遨海洋

fēi tiān dùn dì áo hǎi yáng

Spring Embroidering

Sew mother's apron, baby's bib,
curtains for a brand new wife.
Stitch by stitch and day by day,
we'll sew the pictures into life.

lóng fèng huā niǎo yòu yuān yāng
龍 鳳 花 鳥 又 鴛 鴦

xiān shǒu xiù chéng yì shuāng shuāng
纖 手 繡 成 一 雙 雙

nóng cūn nǚ ér zhēn líng qiǎo
農 村 女 兒 真 靈 巧

zhēn zhēn cì chū yàn rú yáng
針 針 刺 出 艷 如 陽

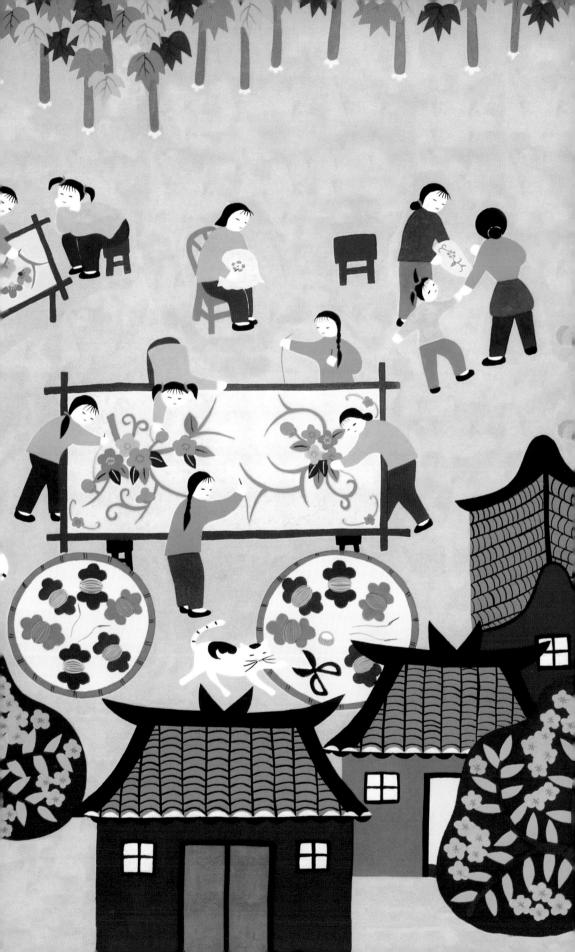

Visiting the Long Corridor

In the Summer Palace, in the Long Corridor, are pictures, in scene after scene, you'll see bridges and ducks and people and boats painted high on the ceilings and beams.

北 京 長 廊 故 事 多
běi jīng cháng láng gù shì duō

遊 人 如 鯽 笑 呵 呵
yóu rén rú jì xiào hē hē

悠 悠 流 水 小 橋 下
yōu yōu liú shuǐ xiǎo qiáo xià

鴨 子 成 群 忙 渡 河
yā zi chéng qún máng dù hé

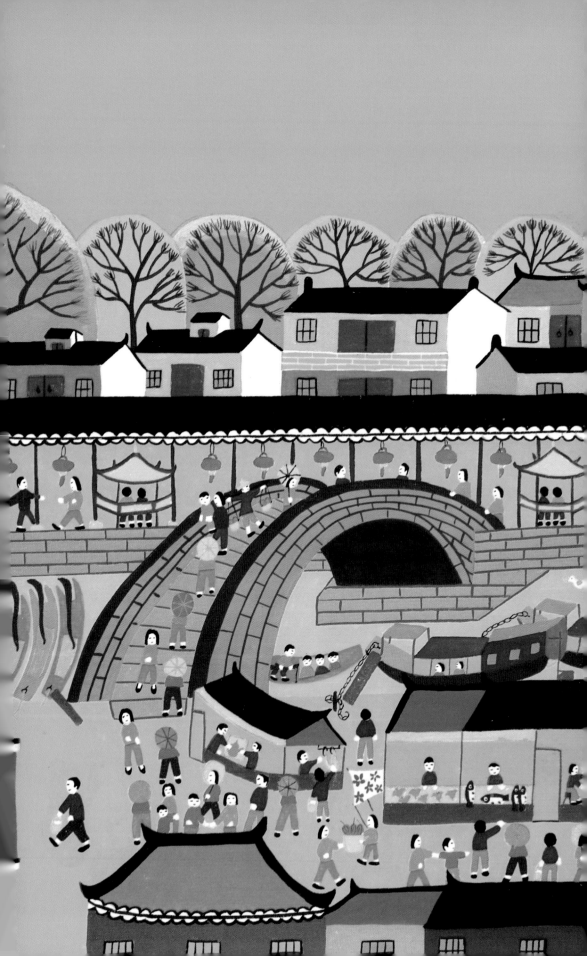

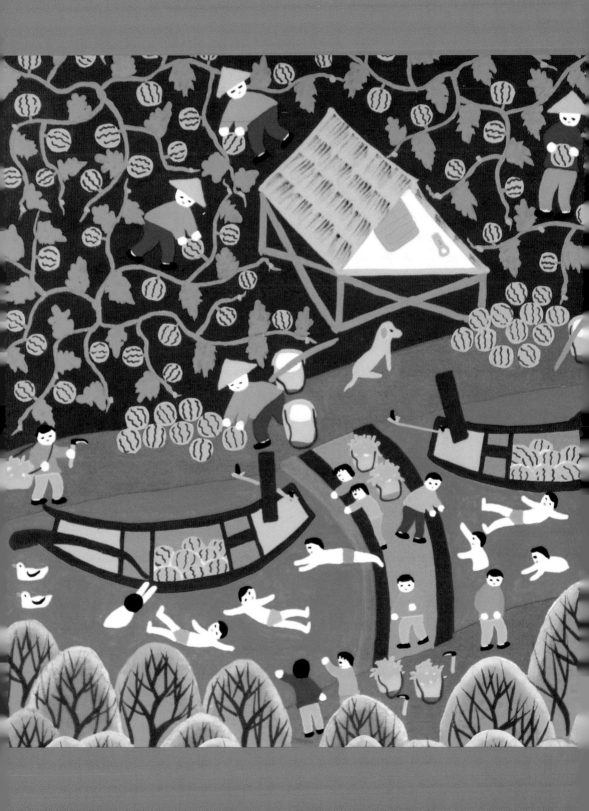

Watermelon Season

Summer comes with a bumper crop of juicy red fruit and seeds inky black. So dive and swim and play and eat the watermelon in your bamboo sack.

xià	rì	xī	guā	shóu
夏	日	西	瓜	熟

mǎn	yuán	guǒ	lù	lù
滿	園	果	碌	碌

jiě	kě	yòu	xiāo	shǔ
解	渴	又	消	暑

ròu	hóng	pí	wài	lù
肉	紅	皮	外	綠

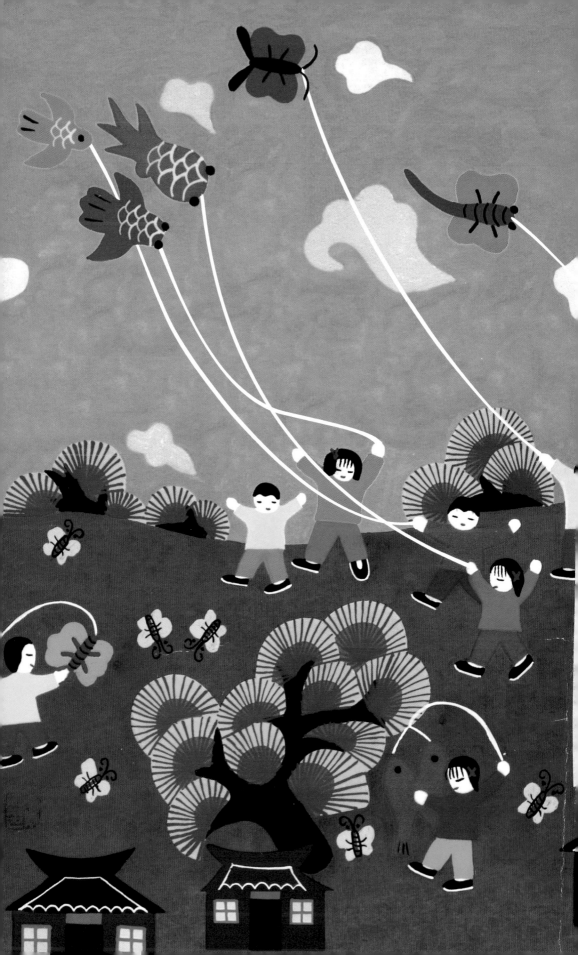

Sky Full of Kites

Silky string and a bamboo pole
hold a butterfly kite in the sky.
We fly her wings close to the
earth so her colors stay close
to our eyes.

蝴　蝶　翩　翩　舞　藍　天
hú　dié　piān　piān　wǔ　lán　tiān

長　長　棉　線　手　中　牽
cháng　cháng　mián　xiàn　shǒu　zhōng　qiān

風　箏　飄　飄　迎　風　送
fēng　zhēng　piāo　piāo　yíng　fēng　sòng

兒　童　歡　樂　線　相　連
ér　tóng　huān　lè　xiàn　xiāng　lián

Autumn Harvest

Play gong, cymbals, trumpet,
drums! Firecrackers!
Cover your ears!
We'll decorate the trees with toys
to celebrate a fruitful year!

你 坐 船
nǐ zuò chuán

我 划 槳
wǒ huá jiǎng

喇 叭 鑼 鼓 一 齊 響
lǎ bā luó gǔ yì qí xiǎng

你 掩 耳 時 我 放 炮 仗
nǐ yǎn ěr shí wǒ fàng pào zhàng

小 鳥 樹 上 高 歌 唱
xiǎo niǎo shù shàng gāo gē chàng

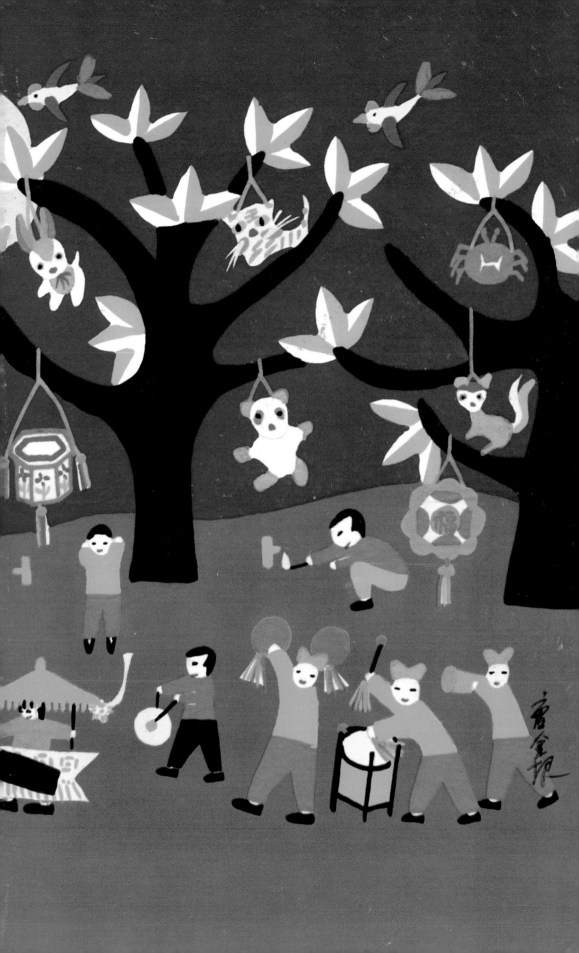

Double Seventh Festival

Sweet rainbow-sewing
Weaver Maid meets her faithful
Cowherd love on the 7th day
of the 7th moon.
Celebrate with them and
pray that you will find
your true love soon.

七月七日喜鵲忙

橋上織女會牛郎

一年一度七夕夜

許個美願如星光

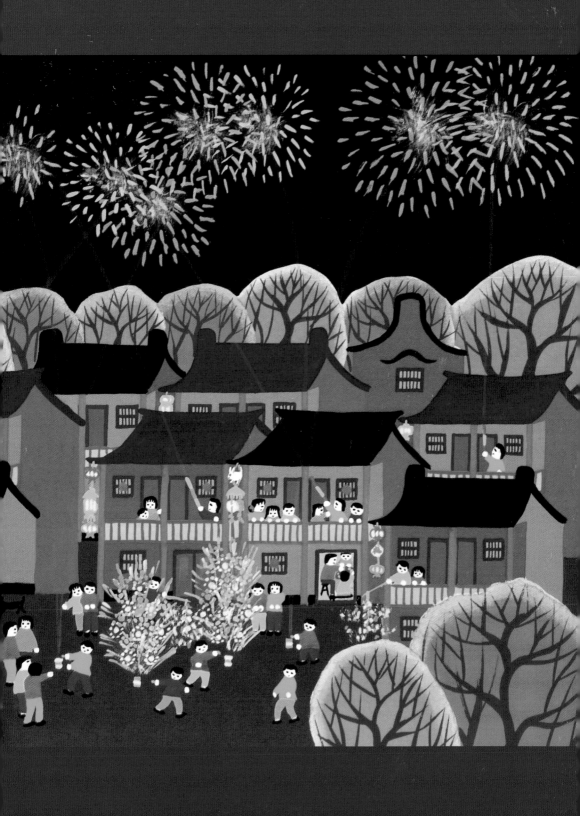

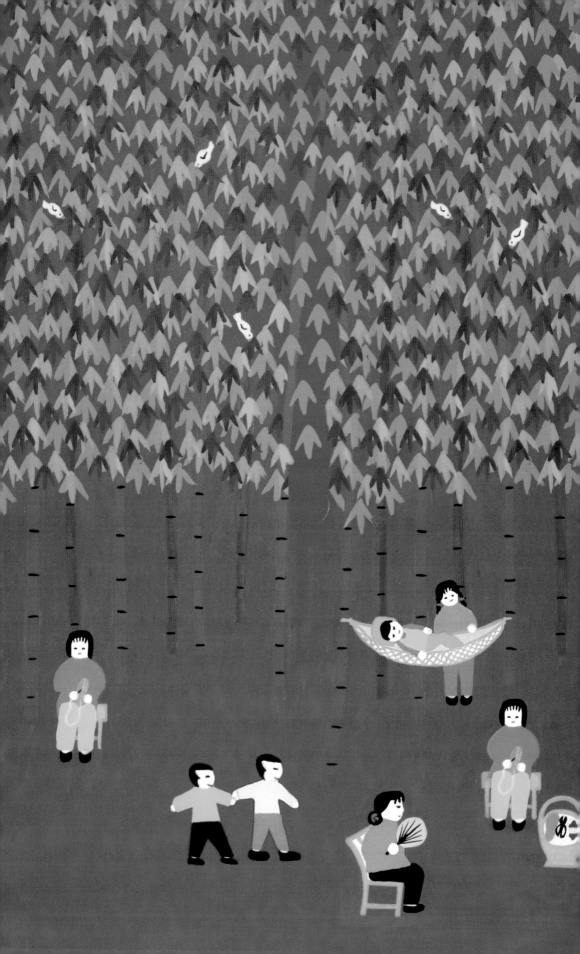

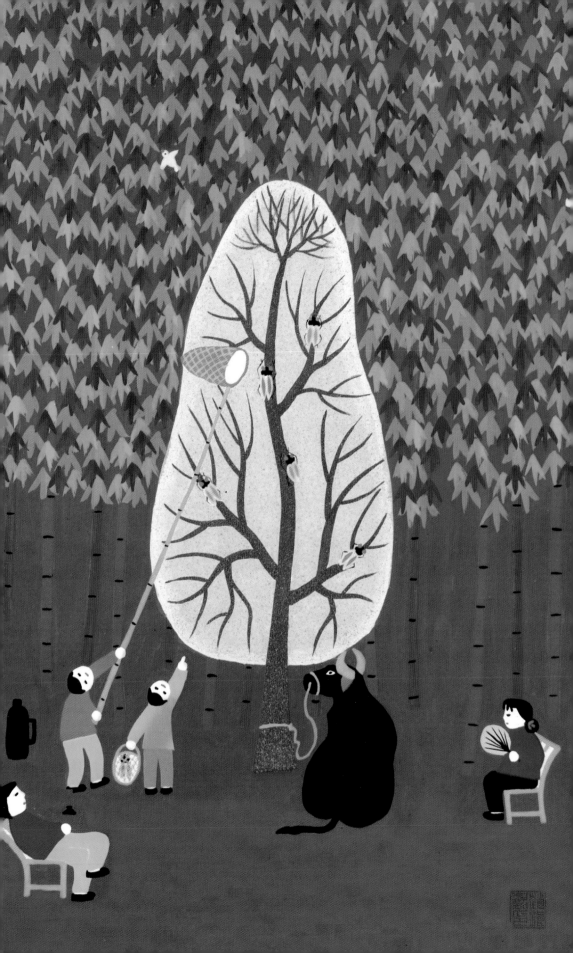

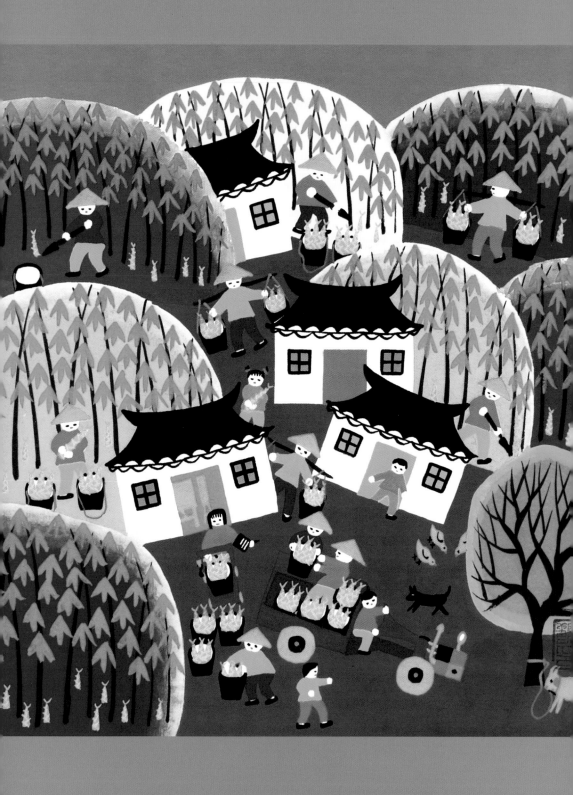

Bamboo Harvest

In winter we harvest the strong
woody stalks for chairs and
chopsticks and flutes.
Pandas will chew on the leafy
bamboo but people will
just eat the shoots.

zhú	sǔn	shōu	chéng	zài	dōng	tiān
竹	筍	收	成	在	冬	天

zhú	luó	mǎn	zài	lè	nián	nián
竹	籮	滿	載	樂	年	年

tiān	lǎng	qì	qīng	zhú	lín	qù
天	朗	氣	清	竹	林	去

xióng	māo	dú	ài	zhī	yè	lián
熊	猫	獨	愛	枝	葉	連

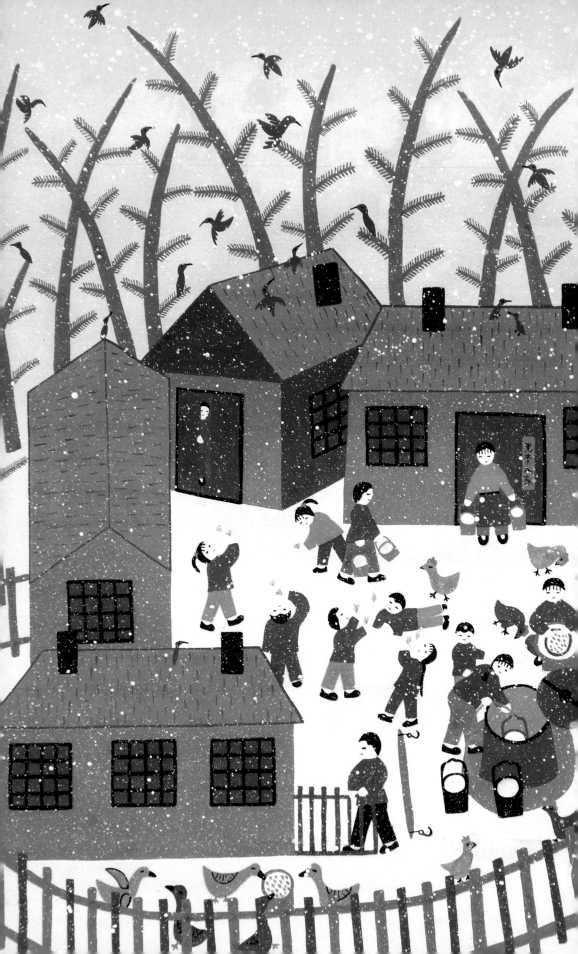

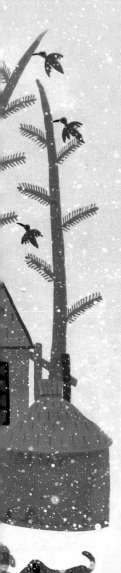

Chicken Feather Game

First, blow chicken feathers to the sky. Then, try to catch them when they fall. Light and white, in the snow they'll hide. You'll win the game if you catch them all!

jī	máo	yíng	yíng	chuī	shàng	tiān
鷄	毛	盈	盈	吹	上	天

xuě	huā	nián	zhe	liǎng	xiāng	lián
雪	花	黏	着	倆	相	連

shuāng	shuāng	yōu	yōu	piāo	piāo	xià
雙	雙	悠	悠	飄	飄	下

ér	tóng	bǔ	zhuō	qīng	mián	mián
兒	童	捕	捉	輕	綿	綿

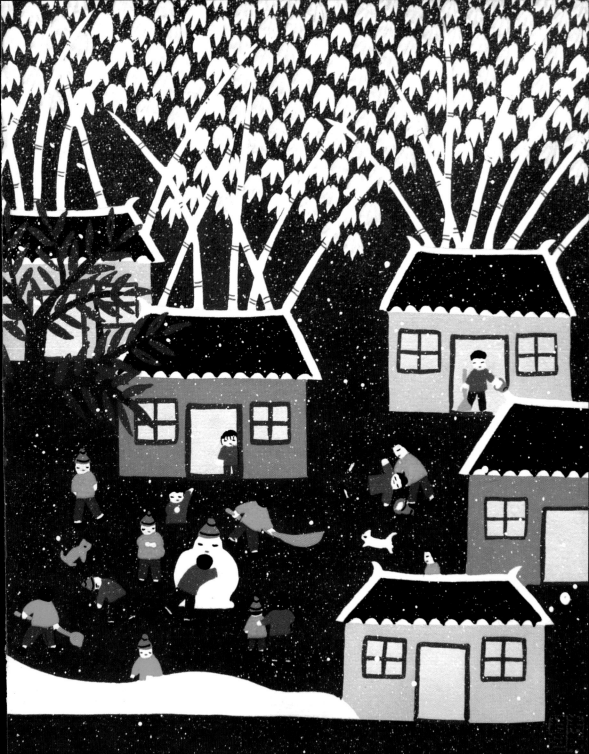

Pile Up a Snowman

One child rolls a snowy little head. A big snow belly tumbles from a sled. Brown mushroom ears, black olive eyes, two families play under cold winter skies.

dōng	rì	shuāng	xuě	fēn	fēn	fēi
冬	日	霜	雪	紛	紛	飛

wū	wài	bái	xuě	duī	mǎn	dì
屋	外	白	雪	堆	滿	地

ér	tóng	shēn	zhuàng	bú	pà	lěng
兒	童	身	壯	不	怕	冷

duī	ge	xuě	rén	dà	yòu	féi
堆	個	雪	人	大	又	肥

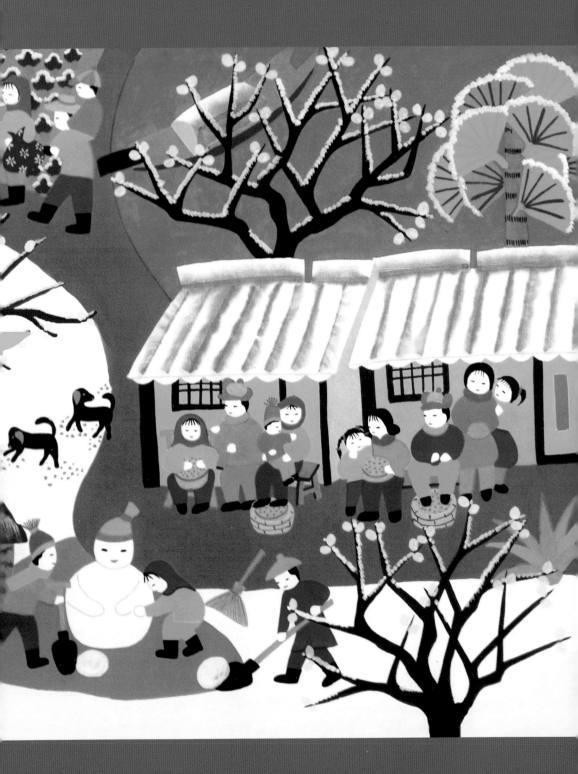

In this book, ThingsAsian proudly presents the artwork of peasant artists from Jinshan, China. These artists paint in sunny kitchens, hay-filled barns, and village art studios. To create bright, lively pictures, the farmers mix tempera paint with chalk. These colorful paintings, and many more, hang in the D.ART Gallery in Shanghai.

Learn more about Chinese peasant art at www.ThingsAsian.com/everydaychina

本書只採用了 D.ART

畫廊小部份的藏畫。

讀者可到上海 D.ART

畫廊作實地參觀或

瀏覽網址 www.d-art.cn

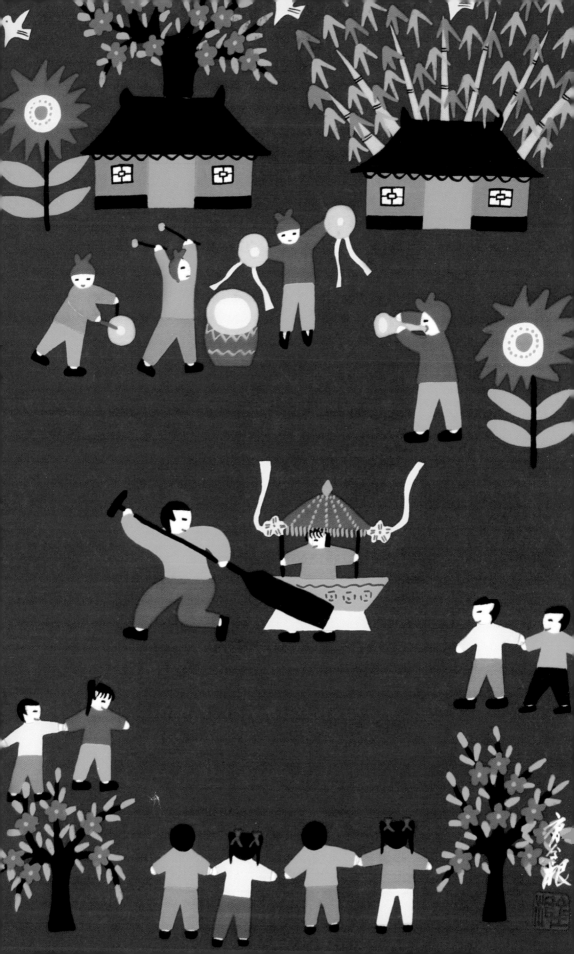

Tricia Morrissey was born in Nairobi, Kenya and spent her childhood in Africa, Greece, Iowa, Georgia and Kansas. She now lives in San Francisco where she writes and edits books for children.

在 非 洲 肯 亞 奈 洛 比 出 生 。 希 臘 , 愛 荷 華 州 , 喬 治 亞 州 , 堪 薩 斯 州 也 是 她 度 過 童 年 的 地 方 。 現 居 三 藩 市 , 工 作 是 編 寫 兒 童 書 籍 。

Ding Sang Mak was born in Guangdong, China. He lived and worked in Hong Kong for 32 years, serving in the Hong Kong Government Civil Service. He now lives in Hawaii with his family and his hobbies include reading, Chinese calligraphy, literature and history.

麥 定 生 原 籍 廣 東 台 山 , 香 港 長 大 , 曾 任 職 香 港 政 府 公 務 員 達 三 十 二 年 。 現 居 夏 威 夷 。 喜 愛 書 法 , 文 學 , 歷 史 及 旅 遊 等 。

楊 世 奇 為 上 海 Ｄ . ＡＲＴ 畫 廊 創 辦 人 。 本 書 農 民 畫 全 部 為 該 畫 廊 藏 畫 。 在 此 謹 向 楊 先 生 致 謝 。

Special thanks to Tony Yang at D.ART Gallery and to the Jinshan artists: Cao Jing-gen, Cao Jin-ying, Cao Yin-ling, Chen Fu-lin, Chen Hui-fang, Pan Hui-wen, Yao Xi-ping, Zhao Long-guan and Zhu Su-zhen.

To buy a painting or learn more about the gallery, visit www.d-art.cn. If you're visiting Shanghai, please visit Tony Yang at D.ART Gallery: No. 63, Nanchang Road, Shanghai, 200020 China. Email: yxdb45@msn.com

Printed and bound by Times Offset, Malaysia
Book design by Janet McKelpin
Book production by Paul Tomanpos, Jr.

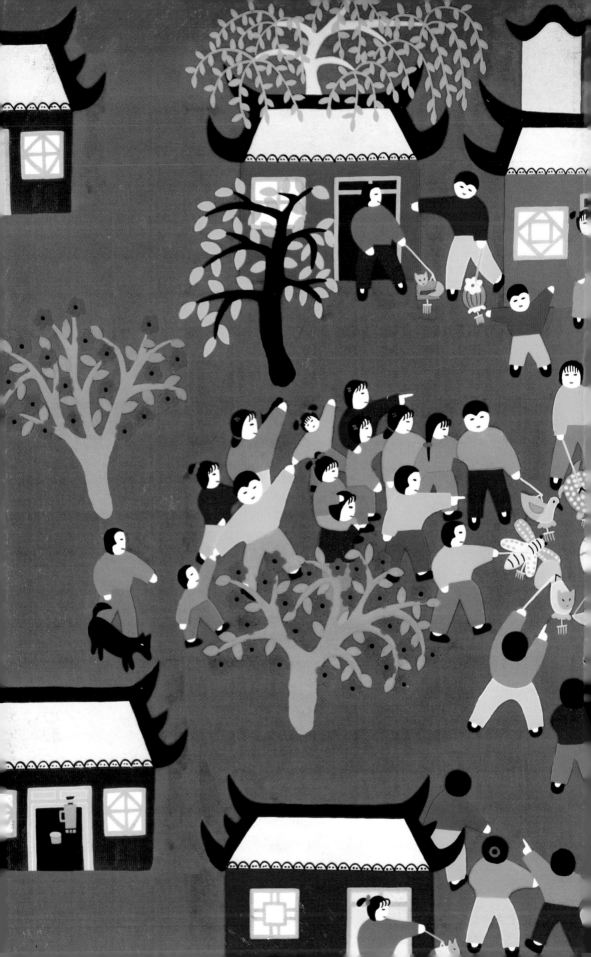

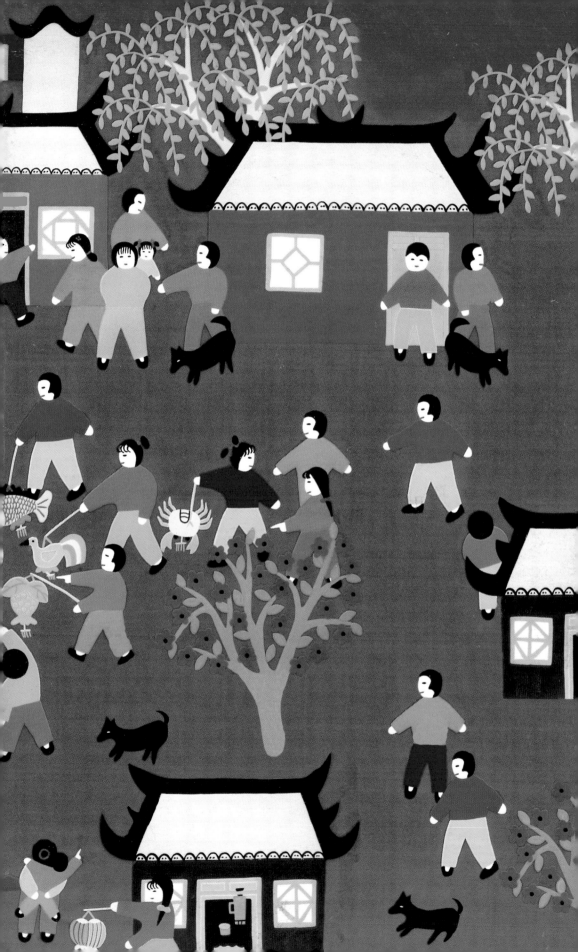

THINGSASIAN PRESS *Experience Asia Through the Eyes of Travelers*

"To know the road ahead, ask those coming back."
(CHINESE PROVERB)

East meets West at ThingsAsian Press, where the secrets of Asia are revealed by the travelers who know them best. Writers who have lived and worked in Asia. Writers with stories to tell about basking on the beaches of Thailand, teaching English conversation in the exclusive salons of Tokyo, trekking in Bhutan, haggling with antique vendors in the back alleys of Shanghai, eating spicy noodles on the streets of Jakarta, photographing the children of Nepal, cycling the length of Vietnam's Highway One, traveling through Laos on the mighty Mekong, and falling in love on the island of Kyushu.

Inspired by the many expert, adventurous and independent contributors who helped us build **ThingsAsian.com**, our publications are intended for both active travelers and those who journey vicariously, on the wings of words.

ThingsAsian Press specializes in travel stories, photo journals, cultural anthologies, destination guides and children's books. We are dedicated to assisting readers explore the cultures of Asia through the eyes of experienced travelers.

www.thingsasianpress.com

MORE TITLES FROM THINGSASIAN PRESS:

HISS! POP! BOOM!
Celebrating Chinese New Year
By Tricia Morrissey;
Illustrations by Kong Lee
6 1/2 x 10 inches; 32 pages;
hardcover; color illustrations
ISBN 0-9715940-7-4
US $12.95

MY MOM IS A DRAGON
And My Dad Is a Boar
By Tricia Morrissey;
Calligraphy by Kong Lee
6 1/2 x 10 inches; 32 pages;
hardcover; color illustrations
ISBN 0-9715940-5-0
US $12.95